Nature in my Dreams

Disaster & Creation

Nature in My Dreams

Disasters And Creations

Nature In Dreams

Disaster And Creations

Nature In My Dreams

Disaster And Creations

Nature In My Dreams

Disaster And Creations

Nature In My Dreams

Disaster And Creations

Nature In My Dreams

Disaster And Creations

Nature In My Dreams

Disaster And Creations

Nature In My Dreams

Disaster And Creations

Nature In My Dreams

Disaster And Creations

Nature In My Dreams

Disaster And Creations

Nature in My Dreams

Disaster & Creation

Nature in My Dreams

Disaster & Creation

Nature in My dreams

Disaster & Creation

Nature in My Dreams

Disaster & Creation

Nature in My Dreams

Disaster & Creation

Nature in My Dreams

Disaster & Creation

Nature in My Dreams

Disaster & Creation

Nature in My Dreams

Disaster & Creation

www.ingramcontent.com/pod-product-compliance
Lightning Source LLC
Chambersburg PA
CBHW080534190526
45169CB00008B/3157